Contents

MEDALLION COLLECTORS' SERIES

edited by Gaby Goldscheider

Children's China

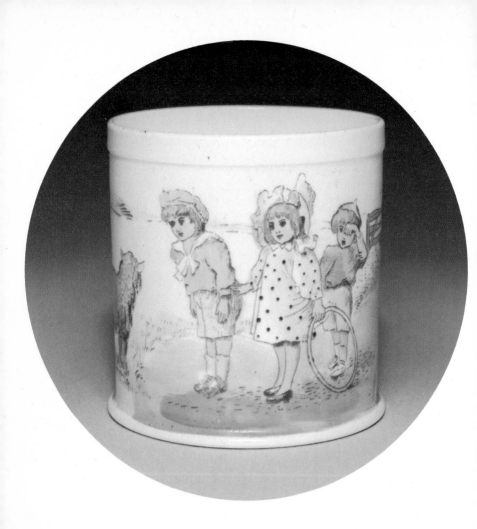

Mug made by the Foley China Works, Longton, Staffs, in 1896. This is one of a set of six

MEDALLION COLLECTORS' SERIES

Children's China

PAULINE FLICK

Constable · London

First published in Great Britain 1983
by Constable and Company Limited
10 Orange Street London WC2H 7EG
Copyright © 1983 by Pauline Flick
ISBN 0 09 463880 2
Set in Linotron Ehrhardt 11pt by
Rowland Phototypesetting Ltd
Bury St Edmunds Suffolk
Printed in Great Britain by
St Edmundsbury Press
Bury St Edmunds Suffolk

List of Illustrations

(Illustrations on pp. 26, 27, 33, 35, 42, 45, 55, 57, 60, 65, 71, 72,
73, 78, 80, *are from the author's collection; illustrations on pp.* 22,
23, 24, 30, 31 & 32, *are from the collection of Gaby Goldscheider)*

Introduction

The history of ceramics made expressly for children's use cannot be entirely separated from the huge subject of earthenware and porcelain generally; virtually every development in pottery-making all over the world could be said to have had a bearing on the design of pieces made for children's food, drink and play. When considering these small objects, therefore, it is important to see them as part of the universal evolution of the potter's art and craft, and of society's changing attitude towards the needs of its children.

Within this context it is sometimes difficult to decide exactly which items fall within the category of 'children's china'. Obviously the term includes nursery mugs and plates – whether they are made of earthenware, porcelain or bone china – infant feeding bottles, and Victorian toy tea services. Logically, a case could be made for including dolls with bisque or glazed china heads, but since doll-making is a vast subject with its own extensive literature this aspect of pottery manufacture is not dealt with here. Nor have I included any of the beautiful scaled-down objects created to satisfy the adult's love of miniatures – the exquisite 'toys' (to use the word in its eighteenth-century sense) produced for example by the Chelsea and Worcester factories; these minute vases, baskets, watering-cans and dozens of other imaginative pieces were intended for display in drawing-room cabinets, and were far too expensive to be played with. I have also excluded, with one or two minor exceptions, pottery figures and ornaments representing children of their pet animals; of course a Staffordshire group portraying a little girl with her rabbit, or a 'fairing' model of a girl with a doll, would appeal strongly to a child; they were not, however, made primarily for children and their rightful place was the kitchen mantel shelf or the parlour whatnot.

Writing in England, I have concentrated on the nursery ceramics used by British children, though even these have a history going back to Roman times. Inevitably the period of the greatest interest to collectors covers the century and a half from about 1780 to the 1930s, a period in which British manufacturers led the world in the mass-production of decorated ware. In the nineteenth century countless tons of transfer-printed pottery were exported from Staffordshire, Swansea, Sunderland and other smaller industrial centres, while at home a fast-growing urban population provided a ready market for this new and astonishingly cheap form of tableware. Small plates and mugs decorated with nursery scenes, or with a child's name, were very popular, and these were quickly joined by tea and dinner services for dolls. Similar toy services were soon being made in Germany, and to a lesser extent in France, and these Continental goods were imported to swell the range of stock offered by Victorian shopkeepers.

Children's china is still produced in great variety, as a look around any department store will show. Older pieces turn up regularly in auction sales and antique fairs, and many families possess treasured Coronation mugs handed out at school treats; in fact, the field is so wide that the aspiring collector may well fear an *embarras de richesse*. However, I hope this brief guide will suggest some of the areas in which an enthusiast could specialise, as well as ways of building up and displaying a representative collection in a limited amount of space.

Background

One of Sir John Millais' most popular paintings is of a group of little girls playing with miniature cups and saucers (see Frontispiece). Millais had almost certainly seen his own daughters amusing themselves with similar toys, for by the second half of the 19th century an enormous variety of children's china was available, ranging from full-sized plates and mugs for use at mealtimes to tiny pieces for putting into dolls' houses. Besides these there were complete dinner and tea services to suit large dolls or small girls, decorated tiles for nursery fireplaces, ewers and basins for washstands, chamber pots and money boxes. The 1900s brought yet more novelties, including stoneware hot-water bottles and tiny porcelain figures for decorating birthday and Christmas cakes; plates, mugs, cups and saucers were brought up to date with a succession of designs featuring popular picturebook characters. Kate Greenaway children were great favourites, soon to be followed by teddy bears and gollywoggs. Mabel Lucie Attwell elves came next, along with Felix the Cat, Little Noddy, Paddington Bear and a whole procession of other old friends.

Many collectors will be content to concentrate on the great variety of interesting and attractive pieces made in the 19th and early 20th centuries, but the history of pottery made for children does, in fact, reach back more than 3,000 years. The British Museum has infant feeding bottles and cups from Mycenae and Cyprus (c.1800 B.C.), and another baby feeder, inscribed 'MAMO', dating from the third century B.C. and found in Southern Italy. Several earthenware feeding bottles used in Britain at the time of the Roman occupation have been discovered and examples are displayed at Colchester and Reading Museums and at the Museum of London.

Anybody interested in *juvenilia* – a convenient blanket term

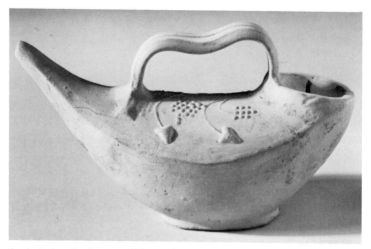

1. An infant feeding vessel dating from the time of the Roman occupation of Britain

now widely, if strictly speaking erroneously, used to cover all man-made objects connected with childhood – soon learns to leap from the Roman era to the 18th century. The intervening 1500 years or so have left little trace of European artifacts intended specifically for children, and the few playthings that have survived from this period are so rare and so obviously confined to princely families that they may reasonably be cited as the exceptions that prove the rule. The English eighteenth century, however, saw the beginnings of great changes on two completely different fronts: on the one hand, parents became far more indulgent towards their children, while, on the other, revolutionary advances in production techniques and methods of transport meant that far more goods of all kinds, including playthings, were available. Influenced by enlightened educationalists like John Locke and Isaac Watts, parents had already begun to realise that a certain amount of amusement might actually benefit their children, provided it could be combined with instruction; and although juvenile literature still aimed to improve the young reader, it did also – for the first time – set

out to entertain him with simple stories and attractive woodcut illustrations. Artists of the time – William Hamilton, George Morland, Adam Buck and many others – showed children actively enjoying themselves with a variety of toys, and wearing much simpler and more suitable clothes than the miniature adult fashions of the past. The Age of Innocence had arrived, and one of the minor but most endearing results was the manufacture of pottery especially designed for small boys and girls.

Utilitarian pieces such as infant feeding bottles, pap boats and quaintly-named 'bubby pots' (for hot milk) were produced by many British potteries in the mid-eighteenth century, replacing earlier pewter and silver utensils. A Bristol Delft feeding bottle, dated 1753, was made in the shape of a Chinaman, and in 1780 Spode made a baby's feeding cup shaped like a duck. The majority of these early feeding vessels were, however, boat-shaped and made to hold a semi-thick mixture of boiled flour, bread or biscuit mashed in water, sometimes augmented with beer or wine. Transfer-printing is the most common form of decoration, but relief ornament was also used: one feeding bottle in cream-coloured earthenware, probably Leeds ware of 1770/80, has a raised grapevine decoration, and, at about the same time, Wedgwood produced a plain cream-coloured pap-boat with scalloped edges. An unmarked mid-nineteenth-century example, in translucent porcelain, is decorated with a moulded basketwork pattern, while a strong stoneware feeding bottle bears an embossed bust of Queen Victoria on one side, and a raised leaf and flower pattern on the other.

The transfer-prints chosen to decorate these infant feeding vessels were largely confined to floral or pastoral scenes in the familiar underglaze blue, but by the early nineteenth century true nursery designs were beginning to appear on plates and mugs intended for slightly older children. By a lucky chance, transfer-printing on earthenware was becoming widespread by this time; the process was quick, cheap and labour-saving, and by the end of the 18th century an avalanche of decorated goods

2. Earthenware pap-boat, Davenport ware, *c.*1820–1860

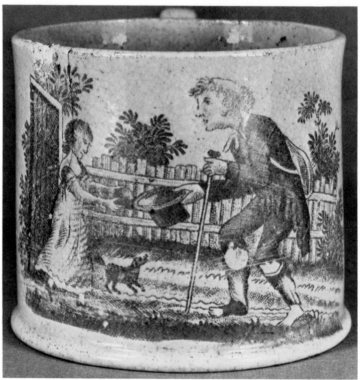

3. 'Girl and Beggar' mug, Newcastle, *c.*1800

was pouring from potteries all over the country and being transported, safely and cheaply, along the newly-built canals to millions of eager buyers. For the first time attractive tableware was within the reach of all but the poorest households, and it was inevitable that soon special pieces for children should be produced along with the ubiquitous Willow Pattern and assorted Classical ruins.

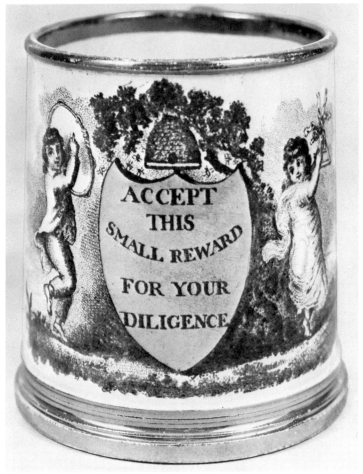

4. 'Reward' mug, decorated with lustre, probably from Sunderland, early nineteenth century

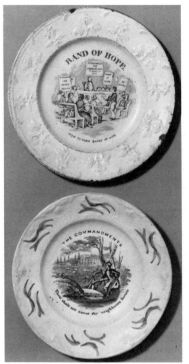

5. A 'Band of Hope' plate, and another forming part of a set illustrating the Ten Commandments. Unmarked earthenware, mid-nineteenth century

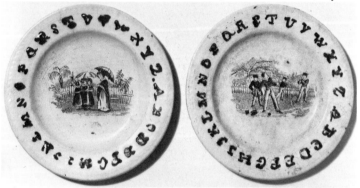

6. The letters of the alphabet have been used to decorate children's ware from the early years of the nineteenth century. On these two plates the moulded letters have been crudely over-painted

Children's China

1. Nursery Tableware

The first pictures on children's mugs and plates still tended to keep the 'improving' character of contemporary juvenile literature, and were, in fact, reflections of its sturdy woodcut illustrations. A Newcastle mug of about 1800 shows a young girl giving something – it looks like a lump of stale and heavy cake – to a tattered beggar (Illus. 3). It may not strike us as very cheerful, but it probably seemed delightful to the mug's original owner. Mugs were often given in recompense for good behaviour or hard work, printed with messages like 'A Present for a Good Girl' and 'Accept this Small Reward for your Diligence' (Illus. 4); plates has moulded borders spelling out good advice – 'Keep Holy the Sabbath Day' and 'Temperance

7. Two unmarked earthenware plates, c.1840, 'The Young Artist' and 'The Cruel Boy', both with moulded alphabet borders

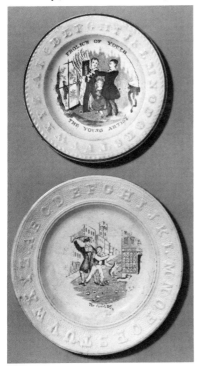

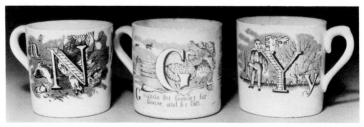

8. Three alphabet mugs, designed to encourage spelling and reading skills. Unmarked, *c*.1840

– A Trifle for My Child' are typical examples; the letters of the alphabet, too, are commonly found in moulded relief running round the border. The pictures in the centre of the plates, and on the mugs, were often scenes from the Bible or the mission field, with a few lines of religious or moral verse. Extracts from Isaac Watts' ever-popular *Divine and Moral Songs* appear on some particularly attractive plates, with illustrations adapted from those in an 1832 edition of the *Songs* (see Illus. 9). Another set features Joseph and his miraculous dreams: Joseph appears to be lying in a mahogany half-tester with sun, moon, stars and other wonders clearly visible through his bedroom window. A tiny plate, only 11.5 cm. in diameter, shows a mother with her little boy on her lap, teaching him a prayer, with a church in the distance and a quaint verse reading:

> And can so kind a Father frown,
> Will he who stoops to care
> For little sparrows falling down,
> Despise an infant's prayer?

A group of Sunderland plates are decorated with transfers illustrating various virtues including 'Attention', 'Meekness' and 'Politeness'

> If little boys and girls were wise
> They'd always be polite.
> For sweet behaviour in a child
> Is a delightful sight.

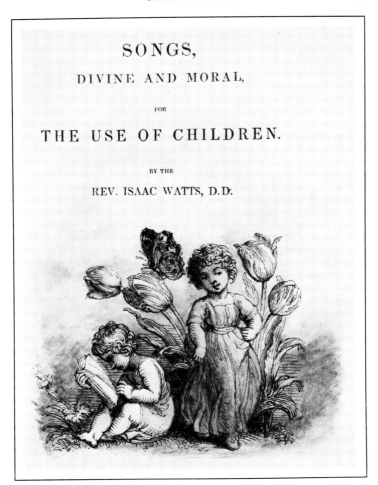

SONGS,

DIVINE AND MORAL,

FOR

THE USE OF CHILDREN.

BY THE

REV. ISAAC WATTS, D.D.

9. Illustration from an 1832 edition of Dr. Isaac Watts' 'Divine and Moral Songs'

They all have the general title of FLOWERS THAT NEVER FADE, and no doubt their improving maxims were learned by heart at many a nursery mealtime.

Other little plates and mugs were completely carefree, intended solely to give pleasure; they have pictures of children playing every sort of game or romping with their pets, scenes

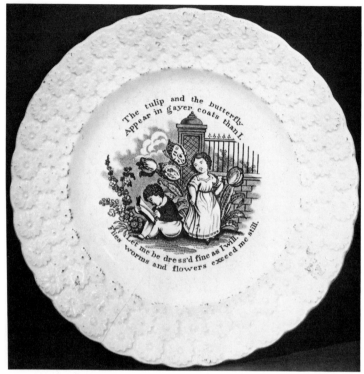

10. Daisy bordered plate decorated with a transfer print adapted from the book illustration shown opposite, *c.*1835–1840.

from nursery rhymes and incidents from well-loved stories. Many of the early ones are unmarked, and it is virtually impossible to attribute them to any particular factory or to say exactly when they were made. The plates measure anything from about 11 to 20 cm. in diameter; most of them are round, but there are a fair number of octagonal examples. There are endless variations in the moulded borders, some having simple messages or the letters of the alphabet, but the great majority being decorated with all sorts of floral mouldings, some left plain white and others daubed with enamel colours or lustre. Daisy patterns are the most common, but one also finds roses and tulips, ferns, ribbon bows, swags and scrolls in profusion.

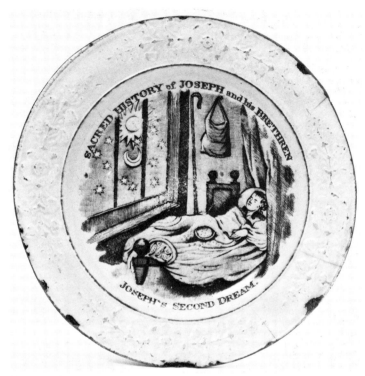

11. One of a series of plates illustrating the story of Joseph and his Brethren. Unmarked, but probably from a Staffordshire pottery, second quarter of the nineteenth century.

Animals are rarer, but I have one tiny plate with an enchanting border of dogs, a rabbit, a goat and a butterfly.

Hundreds of different transfer motifs must have been used on these plates and mugs between about 1800 and the 1870s, when new styles came into fashion. Until about 1850 they were almost all printed in monochrome – sepia, black, magenta, green or blue – sometimes with other colours added afterwards by hand. Printing in more than one colour was popular from the mid-century, but many pieces, particularly the cheaper wares intended for children, still bore monochrome decoration all through the 1800s. The range of subject matter is so wide

12. Four Sunderland plates, the lower three forming part of a series entitled 'Flowers that Never Fade'. The moulded borders are especially fine

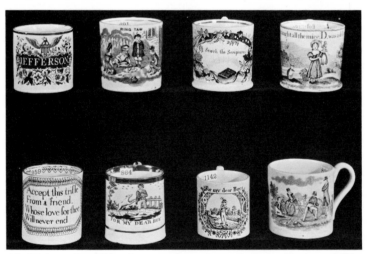

13. Eight early children's mugs from the unrivalled collection of The Society for the Preservation of New England Antiquities, Boston, Mass

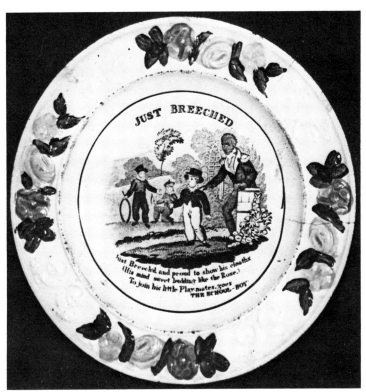

14. 'Just Breeched' shows a little boy promoted from skirts to trousers

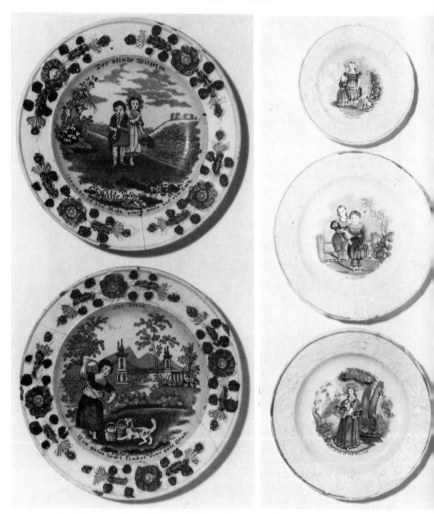

15. Plates made *c.*1850 by William Smith & Co. of The Stafford Pottery, Stockton-on-Tees, Yorkshire. This firm catered for export markets, and many of their printed designs carried German inscriptions. The word WEDGEWOOD (with an 'E') included in the mark has no connection with the Wedgwood factory

16. Three plates showing hand-colouring added to monochrome transfer printing, *c.*1840

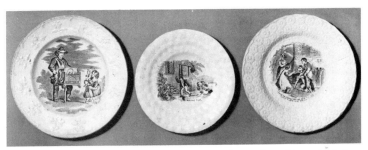

17. Three plates showing children enjoying themselves. Unmarked, but typical of Staffordshire ware of the mid-nineteenth century

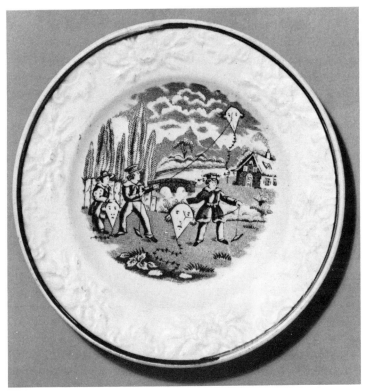

18. Plate with a kite-flying motif

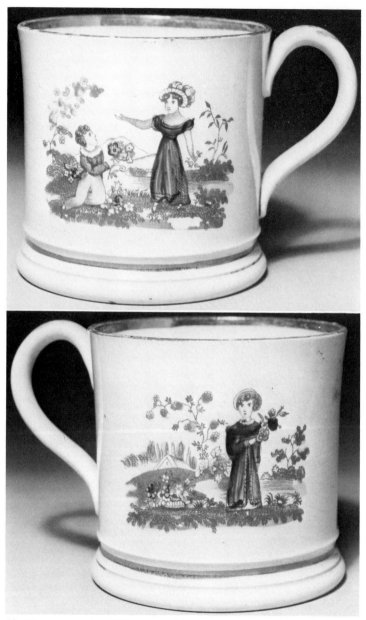

19. Two views of a child's mug, with touches of lustre. Unmarked, early nineteenth century

20. Staffordshire mug showing two working boys. Marked 'B. & L. England' (probably made by Burgess and Leigh, of Burslem. The word 'England' suggests a date of about 1890).

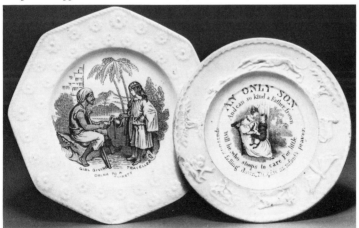

21. These two plates are somewhat out of the usual run, one being octagonal and the other having a moulded border of animals and butterflies. Both unmarked

that no collector can hope to do more than acquire representative examples, or stick to some clearly-defined field, as did one enthusiast who began by limiting himself to plates and mugs bearing pictures of dogs; even so, he found an amazing number of different designs in circulation between about 1810 and 1850, one of the most entertaining being a plate decorated with a print of a loyal hound barking at a pair of fleeing thieves, and accompanied by the following explanatory verses:

> When night enveloped all in shade,
> Who checked the lawless robbers' trade,
> And roused us by the noise he made?
>
> MY TIPPOO
>
> Still share my cake, my crust of bread,
> Still let me gently pat thy head,
> Till I am old and thou are dead –
>
> MY TIPPOO

My own rather haphazard collection includes a pair of small plates printed in green, one with a picture of Bo-Peep wearing spectacles and leading a whippet; the other, called 'The Young Nurse' shows a small girl with a ferocious-looking wrapped-up cat on her lap. Another plate must be the sole survivor of a set of twelve, as it bears the title 'March' and a print of a boy sowing seeds. Mugs seem less plentiful, and perhaps more of them got broken, but there is still a wide variety to choose from. They lack the attraction of the plates' moulded borders of course, but many of them are charmingly decorated with lively transfers showing children playing, dogs, trades and occupations, 'The House that Jack Built' and other familiar rhymes. What appears to be the earliest mug I have is only 6.5 cm. high and printed in red with 'The Cottage Girl' and 'The Cow Boy', very much in the style of William Hamilton against a background of a Classical mansion, park and a lake with swans.

Among the most sought-after of these early children's plates and mugs are the commemorative pieces, issued to mark some national or local event. The Sunderland potteries were parti-

22. An unusual plate with basket-work border. Dogs and other pet animals are unfailingly popular subjects for decorations.

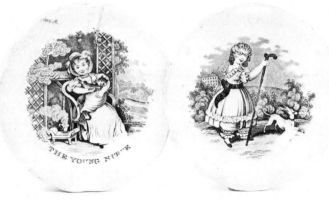

23. A pair of plates with rose-and-tulip moulded borders. Note the spectacles worn by the child on the right

cularly noted for commemorative ware, thousands of articles being produced to celebrate the opening of Wearmouth Bridge in 1796, but innumerable other occasions were recorded in pottery all over the country. Royal births and deaths, politics, battles, horse racing and boxing were all grist to the commemorative mill, and many of these subjects were apparently considered suitable for children's china as well as souvenir pieces for adults. A print showing George III handing a Bible to a schoolboy appeared on a plate issued at the time of the King's death in 1820. The caption reads, 'I hope the time will come when every poor child in my dominions will be able to read the Bible,' the words being based on a conversation George III is said to have had with Joseph Lancaster, a pioneer in the field of education for the poor. A good deal of pottery and porcelain, some of it intended for children, lamented the death of Princess Charlotte, but the antics of her mother, the luckless Caroline, were surely less acceptable topics for nursery tea-tables; nevertheless, several children's plates and mugs were decorated with a portrait of the Queen, usually with the splendid plumed hat she wore for her disembarkation at Dover – so embarrassing to her husband – in January 1820. The Coronation of William IV and Queen Adelaide was commemorated by a matching pair of children's plates, probably from Staffordshire, where similar little plates were made for Victoria's Coronation, decorated with a portrait of the young Queen wearing her hair in a stylish bun and ringlets. The same portrait, very slightly altered, was used on a Swansea mug. The birth of the Prince of Wales in 1841 was widely celebrated, and plates recording this happy event are relatively easy to find; strangely enough, the central motif never seems to be a portrait of a Royal infant, and the 'commemorative' element is restricted to a moulded border spelling out, in bold capitals, 'ALBERT EDWARD PRINCE OF WALES BORN NOV 9 1841'. The printed pictures seem to have been chosen quite at random, sometimes most inappropiately, for one of these plates bears a sombre representation of the Crucifixion; a more cheerful

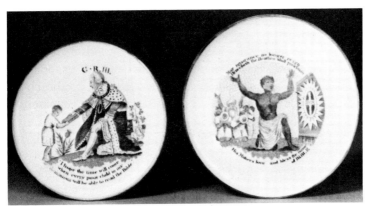

24. Two blue printed miniature plates made in Stoke-on-Trent, *c*.1820–1830. Both carry messages of thanksgiving for the Bible

decoration, though equally unconnected with the event being celebrated, shows a rustic scene with three barefoot little girls dancing, captioned 'The Graces' (Illustration no. 25).

Children's plates were given as souvenirs of the opening of the Thames Tunnel between Rotherhithe and Wapping in 1843; they showed an excellent view of the tunnel, printed in either black or red, surrounded by the familiar roses-and-tulip moulded border found on many other pieces. The sudden death of Sir Robert Peel in 1850 was also commemorated on several children's plates, one view of Constitution Hill, showing exactly where he fell from his horse, being taken from a contemporary engraving in *The Illustrated London News*. A set of plates with the general title 'Incidents of the war' was produced at the time of the Crimean tragedy: Sebastopol and Inkerman seem unsuitable subjects for children's china, but perhaps these military scenes appealed to little boys of the 1850s. A pair of plates, possibly from Swansea, show the battles of Balaklava and Inkerman framed incongruously by moulded animal borders.

The weddings of Victoria's first three children were recorded on children's plates, but by the time the Queen cele-

brated her Jubilees, in 1887 and 1897, commemorative items were designed to appeal to all ages. Early commemorative pieces are always expensive, but a good many examples are on view in various museums (Brighton has an outstanding collection) and are well worth close study because they can be dated so accurately. Using them as guides, the collector is far better

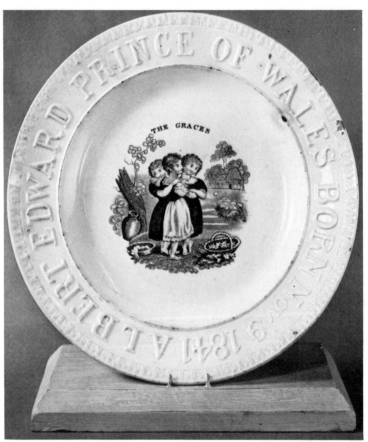

25. Plate commemorating the birth of the Prince of Wales in 1841

able to assess the age and origin of the many 'anonymous' pieces still to be found in antique shops and salerooms.

Nursery Tableware, c.1880–1980
The City Museum at Stoke-on-Trent has a child's plate with a moulded alphabet border made by Edge Malkin & Co. in about 1870, but by this time simple earthenware pieces with monochrome transfer decoration had largely gone out of fashion. The search for fresh ideas to tempt the buying public led to the introduction of many novelties, and a growing

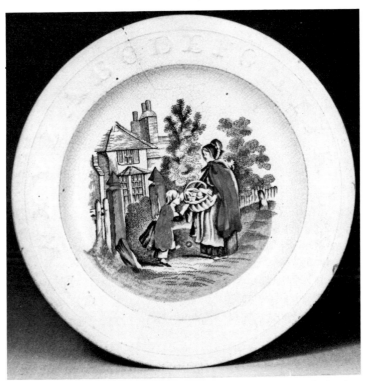

26. Alphabet plate bearing impressed mark 'Edge, Malkin & Co.' a firm active in Staffordshire between 1871 and 1903

27. Cup and plate with decoration inspired by Kate Greenaway illustrations. Late nineteenth century

number of cups, saucers, plates and mugs were made in bone china. Far more hard-wearing than earthenware, this lighter, translucent material gives a completely different character to many nursery items of the late nineteenth century.

The surface decoration, too, is noticeably changed. Just as earlier designers had been influenced by the simple book illustrations of their own time, so manufacturers now looked for inspiration from the work of artists like Walter Crane and Kate Greenaway. Many good-quality pieces with excellent polychrome decoration were imported from Germany, and these in particular reflect the rather sentimental charm of contemporary storybook illustrations, many of which were of course themselves printed in Bavaria.

A set of children's mugs made by the Foley China Works at Longton, in 1896, is typical of these new trends; several years ago I bought a delightful mug for the sake of its 'Baa-baa Black Sheep' decoration (see frontispiece), and it was only when following up the Registration Number printed on the base that I discovered it was one of a set of six. All six designs were

28. Extracts from the official Design Registers showing entries for the Baa Baa Black Sheep mug and four of its companion pieces. Design registered in 1896

registered by Foley's to ensure that they remained exclusive, and 'pulls' from the original copper plates can still be seen at the Public Record Office, as sharp and clear as on the day they

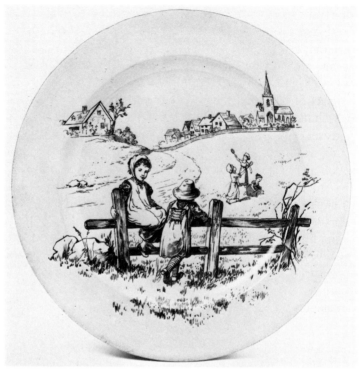

29. A full-size dinner plate from Brownfield's 'Pastimes' series. Here again the decoration shows the influence of Kate Greenaway

were deposited in the files (Illus. 28). It would probably be impossible to build up a complete set of these mugs today, but the basic design records do give an idea, at least, of how attractive the series must have been.

Nursery tableware of this period also becomes more practical. Charming as the moulded floral borders were, they must have been maddening when it came to washing-up, and, in any case, most of the early plates were too small to hold much food. Brownfield's 'Pastimes' dinner plates, however, measure 26 cm. across, quite big enough for an ample helping of meat and vegetables. The decoration, different for each plate, is clearly influenced by Kate Greenaway (Illus. 29). Another practical

innovation was a plate with exceptionally thick and heavy sides, designed to withstand all attempts to overturn it or hurl it to the ground; these useful pieces were, and still are, made by several firms, and early examples usually have the words 'BABY'S PLATE' printed in bold capitals on the side.

Sets of cup, saucer, plate and mug were produced, with matching or related designs. Doulton's Burslem factory made a teaset decorated with various scenes from Alice in Wonderland; this was so popular that it remained in production from 1906 to 1932, although the name of the designer is not recorded. Doulton's early pieces also include a thick-sided 'Baby's Plate' with a Cecil Aldin dog design and several nursery rhyme series, one of which was adapted from illustrations by William Savage Cooper, a regular Royal Academy exhibitor.

Beatrix Potter's animals were being used to decorate tableware as early as 1907, when the Army and Navy Stores' catalogue had illustrations of a teapot, baby plate, milk tumb-

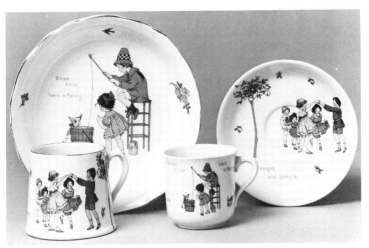

30. An earthenware nursery set made by Royal Doulton, *c*.1920. The name of the designer is not known, but the style is strongly reminiscent of the illustrator Anne Anderson

ler, porridge plate and all the usual items bearing portraits of Peter Rabbit, Squirrel Nutkin, Jeremy Fisher and the mice from *The Tailor of Gloucester*. Six different subjects were specified. The mug cost 8d and the teapot 2/2d, but unfortunately the name of the manufacturer was not included in the announcement. The pieces are quite different from the later Wedgwood 'Peter Rabbit' series, having very little of the background left plain white.

Another artist whose work was most successfully used on nursery china was Mabel Lucie Attwell. Her famous plump children, her green-suited elves and an endearing white puppy gambolled across thousands of cups, saucers, plates and mugs produced by the Shelley factory in the 1920s and 1930s, and following the publicity connected with her centenary in 1979 these pieces are much in demand among collectors.

Familiar cartoon characters are always popular subjects, though with the passing of time their origins tend to get forgotten. In the 1920s and '30s Pip, Squeak and Wilfred were household names and everybody knew they were respectively a dog, penguin and rabbit whose adventures were chronicled in the *Daily Mirror* by A. B. Payne. These remarkable animals had a tremendous following, and Payne's drawings were used on many products, including a nursery tea service. Another tea service of the mid-1920s featured Felix the Cat, a cartoon-film character invented by an Australian – Pat O'Sullivan – in 1922.

Until the outbreak of World War II, Britain's many independent potteries continued to turn out a wide range of children's ware, much of it associated with contemporary trends in juvenile literature or with current events. A cup, saucer and plate set (Illus. 31) commemorated the fascination of wireless sets, and cats' whiskers. Teddy bears – universally beloved since the turn of the century – were popular, as were Mickey Mouse and other Disney characters.

An amusing set of teapot, milk jug and sugar basin, was produced in the early 1930s by Lawleys' Norfolk Pottery at Stoke-on-Trent. The teapot is in the shape of a house, and

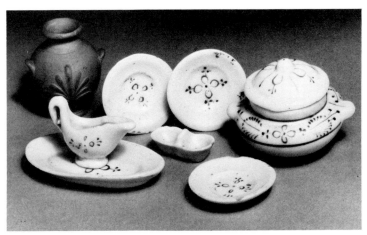

31. Child's cup, saucer and plate marked 'Best Bone Heathcote China Wireless Series', made in England, *c.*1928

strong rectangular shapes were used for the other pieces; the decorations are by J. A. Robinson and the whole *ensemble*, entitled 'The Child's Future Telling Series', is supremely evocative of its period.

Doulton's introduced their 'Bunnykins' ware in 1934 and found it so successful that it is still in production in the eighties. The original anthropomorphic rabbit family was created by Barbara Vernon, who spent her life in an English convent. She supplied Doulton's with dozens of lively drawings showing rabbits busily engaged in various everyday activities, and, when her eyesight failed, the series was continued by Doulton's own designers. Altogether over 150 of these tableaux have appeared, and one or two of them would make an interesting addition to any collection. The more recent ones, designed by Walter Hayward, can often be recognised by the presence of a little mouse among the rabbits. 'Bunnykins' ware is exported all over the world, and since the stories are told pictorially, without the need for written words, it is equally attractive to children of all nationalities. A range of fifteen rabbit ornaments was added to the tableware in the 1970s.

32. Some of Barbara Vernon's drawings of rabbits, used by Royal Doulton for their 'Bunnykins' ware

33. More designs for 'Bunnykins' ware. (By courtesy of Royal Doulton.)

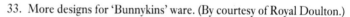

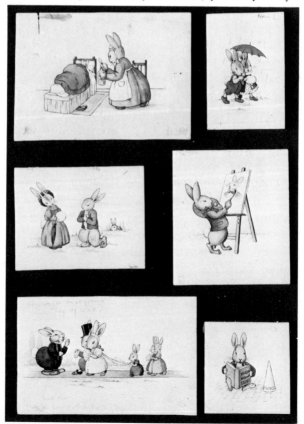

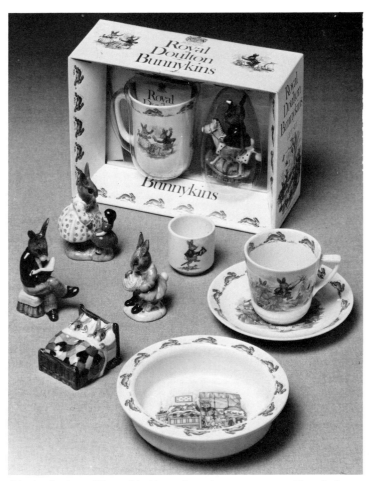

34. A selection of 'Bunnykins' items from the current range. Note the heavy 'baby plate' in the foreground. (By courtesy of Royal Doulton)

Beatrix Potter's famous animals still appear on nursery china. Both Peter Rabbit and Mrs. Tiggy-winkle are featured on plates, mugs and other pieces produced by Wedgwood, and all the favourite characters – good and bad – have been

modelled and turned into nursery ornaments by Beswick. It seems unlikely that they will ever go out of production, but prices rise all the time and collectors might be well advised to invest in a selection as soon as possible.

To a certain extent, unbreakable materials like Melamine have replaced ceramics for infants' and young children's ware, and in any case 'nursery tea' as an institution all but disappeared with the 1930s. Children's china – no longer cheap – is usually bought for some special occasion, and comes complete with its own decorative packaging. Besides nursery classics like Peter Rabbit and 'Bunnykins' these sets include Holly Hobbie, the 'Mr. Men' characters, Snoopy and other current favourites.

Certain quite recent designs were obviously chosen for their nostalgic appeal; Adams, for example, made plates in the 1960s with a Victorian-style monochrome decoration of cats sitting in a basket surrounded by an alphabet border. They also make mugs and plates with numerals and the alphabet, and other pieces printed with an old-fashioned clockface. Johnson Brothers have used Tenniel's Alice in Wonderland illustrations on their children's ware, and Wood's have re-introduced 'For A Good Girl' mugs. Attractive as they all are, they cannot be said to reflect contemporary taste – unless it is a taste for the romanticised past – and collectors would really do better to search out pieces illustrative of the best in contemporary design. One might just be lucky enough to find some of the tableware designed by Eric Ravilious for Wedgwood in 1937, a series which included traditional alphabet bowls given absolutely up-to-the-minute treatment.

2. *Toy Tea and Dinner Services*

The huge expansion of the toy trade in the nineteenth century led to the production of all sorts of pottery playthings, including the most delightful tea and dinner services for dolls or small girls. Indeed, the range of these miniature pieces is so wide, and there are still so many of them about, that they could form a

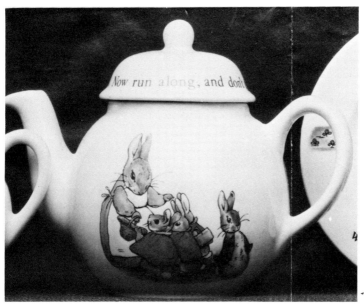

35. A toy teapot (part of a complete set) featuring Beatrix Potter's Peter Rabbit. Made by Wedgwood, and currently available

worthwhile collection on their own. The great firms of Minton, Davenport, Spode, Ridgway and Allerton all made toy services, as did a host of other factories in Staffordshire and elsewhere. It is an absorbing exercise to try to identify the various examples that come one's way, either from marks, often blurred and indistinct, or from characteristic shapes and patterns.

As a general rule, the early toy tea services – nearly always with proper working teapots – are the right size for small children, while the extensive dinner services, which had up to a hundred separate pieces, are suitable for large dolls. The dinner services might have had a dozen each of assorted plates and soup bowls, together with sauce boats, tureens, ladles and vegetable dishes, with all the appropriate lids and stands. The tea services were usually for six children, and came with

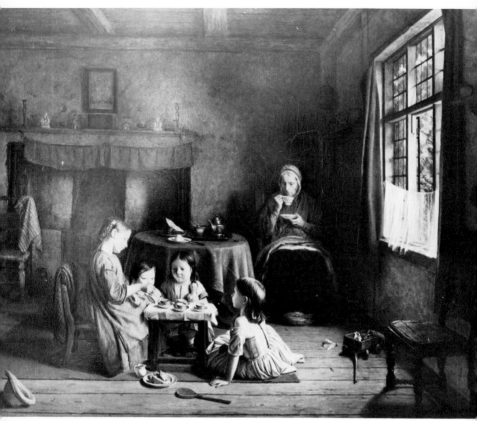

36. Children playing with a toy tea service. A painting by Thomas Webster

enormous slop bowls. Dessert services with a raised stand, and sometimes with leaf-shaped plates, are comparatively much rarer, but even these can still be found by the determined collector.

These mass-produced playthings were natural successors to the expensive porcelain miniatures which were imported from China and also produced by various British and European factories in the second half of the eighteenth century. Mrs. Delany, whose records of these matters are invaluable, has left a description of the 'complete set of young Nankeen china' given

to her seven-year-old great-niece in 1779; this was 'not quite so small as for baby (i.e. doll's) things, nor large eno' for grown ladies,' and consisted of 'twelve tea cups and saucers, six coffee cups and teapot, sugar dish, milk mug, two bread and butter plates.' Letters have been preserved asking ship's captains to bring back children's sets from China. Such pieces were decorated specifically for the European and American markets in the manner of full-size Chinese 'Export' wares, and the Winterthur Museum in Delaware has a set dating from about 1810, printed with a scene obviously adapted from 'Playing at Marbles', one of a very popular series of child studies by William Hamilton. In England, the Caughley factory made miniature porcelain tea and dinner services, some of them printed with the well-known 'fisherman' pattern; these date from about 1785–90. A few early Wedgwood pieces have survived, and Queen Charlotte is known to have ordered two toy sets from this firm.

Most examples of this age and calibre are now in museums, but there is a plentiful supply of earthenware services dating from the first half of the nineteenth century. For obvious reasons few complete sets survived the rough-and-tumble of nursery life, but this can be almost a boon to the collector, since a full dinner service takes up a surprising amount of display space. By all means include one complete service to show its extent, but after this it is really more interesting, and far more economical, to invest in odd pieces from as many different patterns as possible. Needless to say, it is not suggested that a full service, when found, should be broken up. In such a case 'the whole is greater than the sum of the parts'.

Both tea and dinner services were decorated with a bewildering variety of transfer prints, some being miniature replicas of designs used for full-sized services, while others were specially chosen to appeal to children. Landscapes with Classical or romantic ruins are very desirable, and pieces decorated with these scenes are almost always expensive. In 1980 Sotheby's sold part of an early unmarked Staffordshire

37. Pieces from a blue-and-white dinner service for dolls. Staffordshire, mid-nineteenth century. The design is thought to have been inspired by Benjamin Franklin's kite-flying experiments concerned with electricity and lightning. The plates measure approx. 8.5 cm. in diameter

dinner service – a good deal damaged – transfer-printed in black with various Gothic ruins and a church. This made nine times as much as the previous lot, which was a similar part-

service with a far more ordinary blue *chinoiserie* design. The Longport factory of John Rogers & Son, which operated between 1784 and 1836, made a toy dinner service decorated with ruined Indian temples in blue and white, exactly like the 'Monopteros' pattern used for a full-sized set. The designs were taken from a book of Oriental scenery by T. and W. Daniell, published at the end of the 18th century. A Scottish landscape with precipitous mountains and prancing horses appeared on a toy tea service marked 'Caledonian' with the initials 'BG' in a cartouche. This is a typical example of the many toy services made by Benjamin E. Godwin, of Cobridge, Staffordshire, between 1834 and 1841.

Often only a few pieces of a service – sometimes only a single plate – bear the maker's mark or the name of the design, and it is a great help if collectors can meet and compare notes from time to time. Years ago, I found a pretty lidded *sucrier*, obviously once part of a child's tea service, in a London street market. It was transfer-printed in blue, with a floral border and a central picture of a girl milking a goat. Some time later, I managed to buy a 'job lot' of children's china in an auction sale and found a cup and saucer with the identical design, these pieces printed in brown and marked with a title 'Goat' and the initials 'J & R G'. With a little research I was able to attribute the service to John and Robert Godwin, operating in Cobridge between 1834 and 1866, and presumably related to Benjamin Godwin.

Goats were popular pets in Victorian times, and evidently this particular design sold well, as it is still quite easy to find. So is a somewhat similar print showing a girl playing with a goat, seen against a pastoral background with Italianate buildings. This appears on teasets in a dark plum colour, as well as the more usual blue, but so far I have been unable to find a marked piece. A much rarer goat design features Queen Victoria's two eldest children, the Prince of Wales and the Princess Royal, driving in the grounds of Windsor Castle in a four-wheeled carriage drawn by a goat. This is transfer-printed in colours,

and although unmarked, it must date from about 1851 (see facing page 61).

Another tea service shows a girl with a lamb, surrounded by flowers. This is called 'Pett Lamb' and bears the initials E & G P, indicating that it was made by Edward & George Phillips, a Longton firm working between 1822 and 1834. Yet another was printed with a girl looking into a birdcage; on the single saucer in my possession it is marked simply 'Woodlark', but no doubt some other piece somewhere bears the maker's name or initial. An odd plate, sole survivor of a tea service, shows an infant accompanied by two very small dogs and one enormous St. Bernard. An unmarked cup, with a heavy trellis-type border pattern, has a lively zebra in the bottom of the bowl.

Floral designs include Minton's 'Dresden Flowers' pattern, which was used on a variety of children's pieces. It appears, in both blue and brown, on tea services of at least two different shapes made about 1840, and, more unusually, on a doll's toilet set of ewer, basin, soap dish and chamber pot. A Davenport 'Nankin' service, with the impressed mark for 1852, is decorated in shades of blue, grey and brown. All-over 'diaper' patterns, built up from tiny stars, dots and dashes are often found. Many sets, perhaps those in the cheaper range, were decorated with a simple band running round the rim, or a narrow border based on a scroll, or acanthus pattern, or some similar motif.

By the 1870s shapes begin to change, reflecting new styles in full-sized services. Cups and teapots, in particular, are much simpler. A toy tea service made by Powell & Bishop of Hanley in the late 1870s is typical of the trend, although by the late 1880s and '90s shapes were plainer still, the cups being tapered like very small flower pots and having squared handles. The decoration, however, is usually far from simple. Rival firms vied with each other, and with their German competitors, to produce ever new and more appealing prints, and by now it is more usual to find nursery rhymes, fairy stories or playtime scenes than floral or pastoral subjects. Charles Allerton &

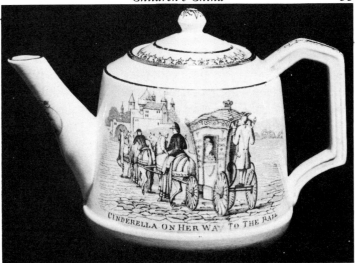

38. Teapot from a toy tea service featuring the story of Cinderella, and made by the Derbyshire firm of T. G. Green & Co. Ltd. in 1889

Sons, an important firm operating in Longton from 1859 to 1942, made several toy tea services, including one decorated with a print of a girl with a large dog, and another featuring Punch with Judy and the Baby. A 'Cinderella' service, which told the whole story with different transfers on plates, saucers and cups, and had a rat running up the teapot's spout, was made in 1889 by T. G. Green & Co. Ltd. of Church Gresley, Derby. This must have been most successful, as it surely deserved to be, for a great many sets are still in existence, printed in either sepia, blue or red.

The powerful German toy industry contributed vast quantities of china playthings to the late nineteenth-century market. Good quality porcelain tea and dinner services were exported to England and the United States, printed in full colour and often decorated with gilding. Nursery rhymes and titles were printed in English, and the greater part of Germany's output was aimed at prosperous Anglo-Saxon customers. Some elegant, high-grade sets were also imported from France, and these tend to be decorated with scaled-down versions of

full-size designs, rather than with nursery illustrations.

Well-known characters from children's literature appeared on toy sets, just as they did on standard nursery tableware. Kate Greenaway children were used on many pieces, both in England and on the Continent, where her work was greatly admired. I have a dolls' dinner service printed with scenes from her 'Mother Goose', unmarked except for the word 'England', which suggests a date around the 1890s (Illus. 39). The shape of this service, with its vegetable dishes like a flattened four-leaved clover, is typical of many turn-of-the-century examples. The Atlas China Works of Stoke-on-Trent made a Kate Greenaway tea service about 1900. (Illus. 40). This is in delicate bone china with full-colour decoration and gilded rims, more like German ceramic toys than the robust English earthenware playthings of earlier years.

Florence Upton's *Two Dutch Dolls and a Golliwogg* were featured on a toy tea service, unmarked, but apparently English. 'Little Red Riding Hood' appeared on another of the Atlas firm's bone china sets. A very unusual porcelain set, probably German, has eleven pieces moulded in a strawberry shape and coloured pink, gold and green. The volume and variety of toy services produced between about 1880 and 1914 is so enormous that the collector can only hope to bring together representative samples, including perhaps French and Japanese pieces, as well as English and German. A glance at the Army and Navy Stores' catalogue for 1907 shows 'China Dinner Sets' from 1/9d to 6/3d, the higher prices being for 'Enamelled' sets. China tea sets – 'latest designs' – and Toilet Sets cost about the same. They came in attractive boxes, and wherever this packaging has survived it should be preserved. Often there is a picture on the lid giving a somewhat exaggerated idea of the contents, and this sort of related material makes a collection more interesting and amusing.

Toy dinner services seem to have been discontinued quite early in the twentieth century, except for really small ones for dolls' houses. Coffee sets are unusual, especially in England,

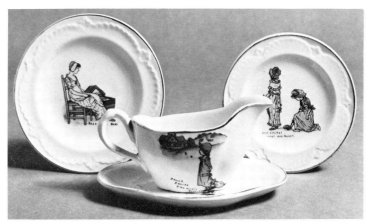

39. Part of a dolls' dinner service (for six) with designs taken from Kate Greenaway's *Mother Goose* marked 'England', *c.*1890

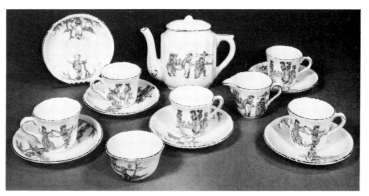

40. Toy tea service made by the Atlas China Works, Stoke-on-Trent, *c.*1900. It is decorated with Kate Greenaway figures

but the Tunstall firm of Hollinshead & Kirkham made an earthenware service called 'Pompadore' (*c.*1900–1910), printed with an all-over floral design in brown; the cups are still large enough for children actually to drink from. As a general rule, tea services got smaller in the 1920s and 1930s, and many cheap little sets were imported from Japan. For some reason

children dressed in Dutch national costume were often used to decorate German examples of this period; the motifs tend to be small and mean, and of no great interest to collectors. Strictly speaking, the much more appealing tin sets of the 1930s are outside the scope of this book, but when found in good condition they can be quite irresistible, especially the Mickey Mouse ones.

Unfortunately, the same cannot be said for modern plastic offerings, and it is difficult to imagine them ever qualifying as collectable bygones. It is, however, still possible to buy small boxed china tea services imported from the Far East, and recently one or two English firms have revived the traditional child's toy tea service, large enough to be actually used by the children themselves. Some have rather dull sprays of flowers as decoration, but Wedgwood have produced a play-size version of their 'Beatrix Potter' series, with pictures and text taken direct from *The Tale of Peter Rabbit*: there are ten pieces altogether, making up a complete tea service for two. The teapot holds half-a-pint (0.3 litres), and the plates, showing Mrs. Rabbit and her family, measure 10 cm. in diameter (see fig. 35).

3. Dolls' House China

The dividing line between 'adult toy' and 'child's plaything' is particularly difficult to establish in the field of dolls' house china. Exquisite miniature objects, in silver and other expensive materials, were made on the Continent in the sixteenth century, and model houses, filled with minute replicas of their owners' belongings, delighted adult collectors in seventeenth-century Holland. Tiny Delft pieces date from this period, and when in the eighteenth century the dolls'-house fashion spread to England, enthusiasts could buy porcelain miniatures, both Chinese and European, to equip their Lilliputian households. It is often suggested that these early baby-houses, as they were called by the Georgians, were exclusively for the amusement of grown-ups, but there is ample evidence of children having toy

houses at this time, and at least one description of boisterous, unsupervised play resulting in serious damage to dolls' house contents. The 'crockery' and tableware of this period were more likely to have been made of pewter or wood than of china, and wooden services continued to be made for dolls' houses for a very long time. The Drew Dolls' House at the Bethnal Green Museum has a beautiful display of painted wooden plates dating from the 1860s, and it is still possible to find, in toyshops of the 1980s, wooden apples that come in half to reveal tiny wooden tea sets.

Very small earthenware pieces date from the first quarter of the nineteenth century, and include white glazed oval platters complete with flat pierced liners for draining away fat. A pair of octagonal plates, commemorating the wedding of Queen Victoria and Prince Albert in 1840, are so small that they are thought to have been made for dolls' houses. Certainly, Staffordshire potters of this time were producing dolls' house dinner services in blue-and-white transfer-printed ware, similar to those for larger dolls. There is a lavish set in the kitchen of the Norwich Baby House at the Strangers' Hall Museum in Norwich, comprising plates, oval dishes, lidded tureens and sauceboats. It is considerably too large for the doll inmates, but scale did not unduly worry Victorian children, and giant dishes are commonplace.

German toy-makers were more meticulous in these matters, and produced dolls' house furniture in several sizes. One particular dinner service must have been made in tens of thousands, as it has survived more or less intact in many old dolls' houses: it has a white background with a rather spindly blue decoration, apparently derived from *Copenhagen* ware. Like other German toys, it came packed in round, or oval, pine boxes with decorated lids.

Elegant services with delicate decoration were produced by the Meissen factory; some of these pieces had realistic plaster food attached to them. A most elaborate service, incredibly extensive, is among the treasures of Arundel's Museum of

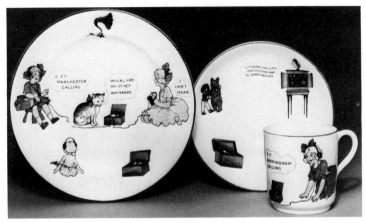

41. Part of a dolls' house dinner service, decorated in blue. Nineteenth century, German. The vase in the background probably dates from the late nineteenth century, and may have come from a cracker.

Curiosity; decorated with flowers inside a wide green border; it even includes crescent-shaped salad plates.

Many of the earlier dolls' house tea services were made of milky glass, and china services on round trays seem to belong to the early twentieth century. Most came from Germany, but they were also made in France, and one unusual French set has lidded chocolate pots in place of tea cups. A pretty flower-sprigged breakfast set on an oblong tray was made in Saxony in the early 1920s for Queen Mary's Dolls' House, and must have been duplicated many times over, as examples crop up in many collections. A tea service, white with gilding, was specially produced by Doulton's for this famous model mansion.

Apart from tableware, Victorian dolls' houses were supplied with toilet sets. Ewers, basins, slop pails with wicker handles, and chamber pots are usually found in white glazed earthenware, but decorated sets were also made. As real-life bathrooms came into general use, so tiny china baths, wash-basins and W.C. pans – which had substantial wooden covers held on by wire – were provided for dolls' houses. These were certainly made up to the late 1930s, some of them fashionably coloured.

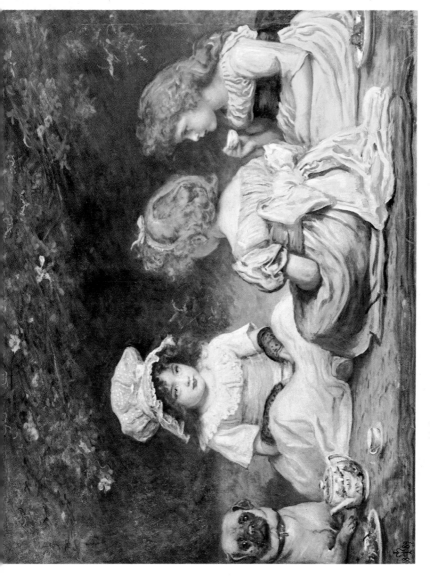

'Afternoon Tea' by Sir John Everett Millais, PRA (1829–1896)

Pieces from a toy tea service showing Queen Victoria's two eldest children riding in a goat cart at Windsor Castle. c.1850

China dolls' house ornaments are legion. Parian statues and portrait busts, cats, dogs and guinea-pigs, Wedgwood vases, mugs with a distinctive chequered pattern, sets of brown stoneware jugs, spill vases, and other assorted treasures, were crowded into Victorian dolls' rooms. Some of these came out of Christmas crackers, hugely popular from the 1880s.

The problem of differentiating between children's playthings and adult miniatures has taken a new twist since grown-ups have rediscovered the charm of dolls' houses. Model houses to be filled with furniture and accessories in perfect scale are enthusiastically collected by adults on both sides of the Atlantic, and a growing number of craftsmen and women are working full-time on the production of incredibly fine pieces of equipment. These hand-made pieces are too expensive to be given to children, but various manufacturers – including some in the Far East – have reacted to the collecting mania by turning out cheaper versions. Wooden harmoniums, for example, scaled down to one-twelfth of full-size, are made in Korea – one can only speculate as to what the industrious Oriental workmen imagine they are constructing. Ceramic toilet seat and bathroom suites come from the same source, all consciously 'old fashioned' and unashamedly inspired by Victorian dolls' house originals. A selection of china ornaments, including a tiny jug shaped like a cat, is also available, but all these pieces really come into the 'replica' category, and while they are useful to certain dolls' house enthusiasts, they are not altogether suitable for inclusion in a collection of children's china.

4. Ceramic Tiles

Enormous numbers of ornamental tiles were used in Victorian and Edwardian buildings, being recommended particularly for 'hearths, fireplaces, wall linings, baths, friezes, skirtings, flower boxes and cabinet work'. Rows of brightly-coloured, highly-glazed tiles are often still to be seen on either side of a cast-iron fireplace – graphically described in contemporary

trade catalogues as 'grate cheeks' – or along the back of an old washstand, and although dealers no longer virtually give them away, run-of-the-mill examples are still comparatively cheap. Tiles were decorated with innumerable different designs, either transfer-printed, hand-painted or moulded in low relief, and they illustrate every change in fashion, from Gothic revival to art nouveau. Amongst countless geometric and abstract patterns, flower subjects and pastoral landscapes, the keen collector will discover a wide range of designs featuring children and storybook characters. To some extent these pictorial tiles were intended for general use all over the house, appealing as they did to the Victorians' taste for sentimental childhood studies. Some were even used to cover butchers' and fishmongers' slabs, but the majority were bought specifically for nursery rooms. Today it is easy to forget that in an era of large families and substantial houses – well into this century, in fact – it was quite usual for accommodation to be permanently set aside for successive generations of children, with iron bars fitted to the windows, gates to the landing, and all the decorations – wallpaper, fabric and tiles – chosen to suit the young.

A group of nursery tiles makes an interesting addition to a collection of children's china. A number of eminent late nineteenth-century artists worked for pottery manufacturers, the best-known being Walter Crane, who designed a wide range of tiles for both children and adults to complement his exquisite wallpapers. His nursery tiles are unlikely to be cheap, but considering his extraordinary influence on all aspects of decorative art, as well as his importance as a children's book illustrator, a Crane example must come top of the list of any collector's *desiderata*. Writing in the *Easter Art Annual* for 1898, Crane recalled his work as a freelance designer for Maw & Co., the celebrated Shropshire tile manufacturer. In about 1874 he had, he said, produced designs for six- and eight-inch fireplace tiles 'much in the style of my nursery books, of such characters as "Mistress Mary", "Boy Blue", "Bo Peep" and "Tom the Piper's Son"'. The outlines were transfer-printed and then

42. Two nursery tiles with a Walter Crane design

colour was added by hand. According to Crane's recollections, these tiles pre-dated his book *The Baby's Opera*, and he rather thought that 'the square form, size and treatment of the six-inch tiles really suggested the adoption of the same size and treatment for the book.' First shown at the Paris International Exhibition of 1878, these tiles were evidently very successful as they were still in production in 1895, when they could be bought at half-a-crown each – certainly not cheap – at the Manchester Arts and Crafts Exhibition.

Other Crane designs taken from the *Baby's Opera* and *Baby's Bouquet* have been found hand-painted on Minton tiles, but no trace of such a series has so far come to light in the Minton archives. The painting is of a professional standard and may have been done by specialist tile decorators using Minton 'blanks'. Illustrations from the *Baby's Own Alphabet* ('Great A, Little A, Bouncing B' etc.) also appear on tiles, transfer-printed in brown on a pale cream ground. These tiles bear no maker's mark and possibly the designs were pirated, as Crane makes no mention of their use on tiles in his 1898 article.

Another much-loved artist whose work influenced the de-

sign of nursery tiles was Kate Greenaway. Mintons' Wages Book for 1882 records a payment to one of their foremost engravers for work on 'butterflies and Kate Greenaway subjects.' In 1881 the Burslem firm of T. & R. Boote registered designs for a set of four tiles symbolising the Seasons, and decorated with typical Greenaway children.

The Seasons and *The Months* were popular subjects for tile manufacturers, and were interpreted in many different ways. One of the most sought-after sets is the Wedgwood 'Months' series entitled *Old English* or *Early English*, and consisting of twelve studies of children in seasonal settings – March winds, April showers, and so on. Registered in 1878, these Wedgwood designs are strongly reminiscent of Kate Greenaway drawings; they are usually found printed in blue, but brown has also been recorded.

The charming December cherub with his Christmas tree printed in browns and pinks on an unmarked tile (illus. no. 43), is the sole survivor of a set of a dozen that once surrounded the fireplace of a house in Brighton. It would be a challenging project to try and reassemble the complete year.

The seven days of the week provide a variation on the same theme. In about 1880 Ellen E. Houghton – a talented children's book illustrator – designed a set of tiles for Minton which show plump little figures occupying themselves in ways appropriate to each day – walking to church, doing the washing, going to market, and other familiar activities.

Many tiles were decorated with nursery rhyme or fairy story scenes, or with children playing. The *Punch* artist, John Moyr Smith, was a prolific designer of tiles, including a *Fairy Tales* series of a dozen for Minton. Introduced in about 1874, these tiles are instantly recognisable from their figures in mock-mediaeval costume and the heavy circular frame enclosing each little scene. Moyr Smith also designed for the rival tile firm of Minton, Hollins & Co. Their eight-inch *Nursery Rhyme* set, block-printed in black on a white ground, included Jack Sprat, Marjery Daw, Miss Muffet, Old King Cole, the Queen

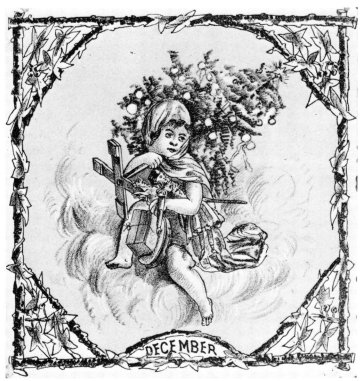

43. 'December' tile from a set of twelve, originally fixed round a fireplace.
Unmarked, *c.*1880–1890

of Hearts and Jack Horner. Again, the picture occupies a
circular space within the square tile, a long-established con-
vention in tile decoration, and effective because it results in
such a satisfactory all-over design when the components are
put together.

Tiles attributable to a well-known artist, or to a firm such as
Wedgwood, will obviously be the most expensive to collect, but
there are many very attractive anonymous pictorial tiles from
bygone nurseries, which can be bought for quite reasonable
sums. A design of two children and a puppy in my own
collection probably came from some long forgotten picture

44. Seventeenth century Dutch tiles, featuring children's games

book, and is typical of dozens of late, nineteenth-century examples from Maws, Minton's China Works, Minton Hollins & Co., or from smaller manufacturers, some of whom did not mark their products.

Two other types of tile with childhood associations should be noted. First come seventeenth- and eighteenth-century Dutch tiles illustrating various children's games. At a time when Dutch painters were very much taken up with their domestic surroundings, it was natural that tile decorations should echo the same themes, and studies of children at play were very popular. Quantities of these tiles, painted in blue or manganese, were exported all over Europe. Within the past few

45. Doulton Tile Panel, 'Mary, Mary, Quite Contrary', designed by Margaret Thompson, *c.*1900 for University College Hospital, London.

years a collector was lucky enough to get hold of some of these when alterations were being carried out to a house in London's Park Lane. They photograph beautifully, and if all else fails, then a display of children's china might usefully include a colour reproduction of a group of these early tiles.

The second 'fringe' category consists of tile panels produced for children's hospitals. Because of their hygienic qualities and their brightness, painted pictorial tiles were frequently used for the walls of children's wards. Doulton's were the main suppliers of tile panels, and in the late 1890s and early 1900s their designers, William Rowe and Margaret Thompson, worked on various schemes involving nursery rhyme subjects. Two children's wards at St. Thomas' Hospital, London, were originally decorated with these panels and although the building has been extensively altered, the nursery rhyme decorations have been preserved. Other panels from the old Royal Hospital for Children & Women have also been resited at nearby St. Thomas'.

A feast of Doulton tiles still awaits the visitor to Newcastle-upon-Tyne's Royal Victoria Infirmary, where more than fifty panels designed by Margaret Thompson, William Rowe, and J. H. McLennan were used to decorate the children's wards; others survive at the Buchanan Hospital, Hastings. Doultons exported nursery rhyme panels all over the world, and a scheme still survives in the Wellington Hospital, New Zealand; others are reputed to have been used in Poonah. There were about fifty tiles to each picture, and, irresistible as such a rarity would be to anybody lucky enough to stumble upon one, a panel of this size might be difficult to display in a limited space. At Bethnal Green Museum, however, visitors can admire the stylish *Mary, Mary Quite Contrary* panel, designed and painted by Margaret Thompson and originally in the children's ward of London's University College Hospital (illustration no. 45).

Miscellaneous Pieces

From time to time, collectors may come across intriguing items falling outside any of the main categories of children's china. A stoneware hot water bottle, for example, or a miniature ornament from a birthday cake, could well find a place in a display of nursery ceramics, and a representative selection from any of the following groups would help to build up a complete picture of the potter's involvement with childhood.

5. Cradles

Miniature pottery cradles, often with slipware decoration, were made in Staffordshire in the eighteenth and early nineteenth centuries. It is thought that they were sometimes given to newly-married couples, but more often they were presented to a mother on the birth of her baby, with money or some small gift tucked inside. The decoration on the cradle frequently included the child's name and the date of birth

46. Model cradle, red earthenware decorated with brown and white slip, and glazed. English (Staffordshire), *c.*1700. Length 10¾"

which is an invaluable guide when placing these ornaments in their correct chronological position. Some examples have a moulded design simulating wickerwork; some have a ceramic baby fixed inside.

6. Plaques
The renowned Lowestoft porcelain factory, which flourished from 1757 until the end of the eighteenth century, produced many items to order for local Suffolk families in commemoration of births, marriages, and even deaths. The factory was unique in making small porcelain discs about 7.5 cm. across, bearing a child's name and date of birth; some of them were made for the children of factory workers. These mementoes, known as 'birth tablets', are very rare indeed.

7. Toilet Sets
Although doll-size toilet sets are quite common, only a very few made specifically for children seem to have survived. Small chamber pots are relatively plentiful, many having the familiar blue transfer-printed decoration; a more unusual one dating from about 1835 has 'A present for Lucy' and a picture of two children printed in black. Ewers and basins intended for nursery washstands are rarely to be found, and it may be that very few were made, since the weight of water in a full-sized ewer or basin would be too great for a child to handle safely. However, a search through the Patent Office Design Registers has yielded up a set of four transfers showing little girls representing the Seasons and labelled 'ornaments for a ewer'. These designs were registered by Bates Elliot and Co. of Burslem in the 1870s. In my own collection I have a full-sized Edwardian ewer and basin set decorated with Lewis Baumer storybook characters, obviously intended for a night-nursery (illustration no. 47).

Stand-up toothbrush holders appear to have been an innovation of the 1930s, and featured current favourites from Walt Disney cartoon films. Others were based on Mabel Lucie Attwell children.

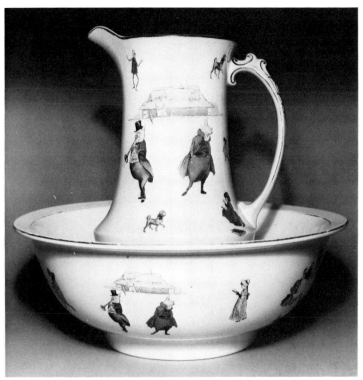

47. Edwardian ewer and basin, full-size, decorated with Lewis Baumer characters

8. Hot Water Bottles

Miniature hot water bottles – not to be confused with hand or muff warmers – were made for dolls, as well as for warming chilly cots. In about 1910, Doulton's Lambeth factory produced bottles in mottled blue-green stoneware, with applied reliefs spelling out the word 'Baby'. They are bolster-shaped, with a knob for carrying at one end and a screw cap on top. The same traditional shape was used at Bourne's Denby factory for brown stoneware miniature bottles. An upright bottle, the 'shoulders' pierced to take a carrying cord, has a picture of a child wearing a cosy sleeping suit and the words 'The Little

48. A baby's hot water bottle in mottled blue-green stoneware with applied reliefs, made by Doultons, Lambeth, *c.*1910

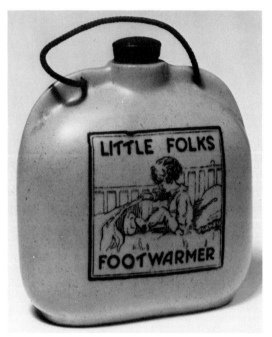

49. The 'Little Folks Footwarmer', sold by Harrods in the 1920s

Folks' Foot Warmer'; this is unmarked, but it appears in a Harrods' catalogue of the mid-1920s (illustration no. 49).

9. Biscuit Caskets

These were another of Doulton's specialist products. In the early 1900s, biscuit and confectionery manufacturers vied with each other in packaging their goods in attractive containers, particularly for the Christmas trade. Although most of these highly imaginative containers were made of tin, Huntley & Palmer did for a time pack their biscuits in ceramic caskets which were shaped rather like a bombé chest of drawers. The top, which lifted off, was slightly convex and decorated with nursery rhyme designs by William Savage Cooper. These caskets were made for Huntley & Palmer by Doulton and are marked accordingly on the underside of the lids (Illus. 50).

50. Lid of a biscuit casket made by Doulton for Huntley & Palmer, 1905. The designer was W. Savage Cooper. In the foreground: an Easter egg-cup of the 1930s, made in Japan

10. *Money Boxes*

Pottery money boxes have a history going back at least to the mid-eighteenth century, when they were often given slipware decoration. Pottery piggy-banks are perennial favourites, probably because the pig used to be a supremely economical animal to keep, and so symbolised thrift. In the first half of the nineteenth century Sunderland's Low Ford Pottery was noted for the production of all sorts of novelty and gift ware, including money boxes. One of these has a coloured design of a mother and children in a garden. If anyone is looking for a modern example, Wedgwood have added a twelve-sided money box to their Peter Rabbit range.

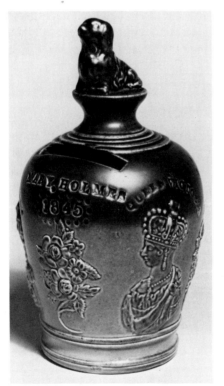

51. Staffordshire salt-glazed money box, with relief decoration. Dated 1845

11. Easter Eggs

Two pottery Easter eggs now in Sunderland Museum were probably also made by the Low Ford works. The names *John Clow* and *Jane Clow* have been hand-written on one side and the other is transfer-printed with dancing figures. The collector may be lucky enough to track down similar eggs, and will certainly be able to find some of the fanciful mugs and egg-cups which originally held chocolate Easter eggs. Although Easter eggs are still sold in various china containers, today's examples tend to lack the character of the custom-made pieces dating from the 1920s and '30s, when egg-cups in all sorts of surprising shapes were produced especially for the Easter confectionery trade. Hens and chickens are naturally the most commonplace subjects, but I have seen an egg-cup shaped like a Noah's Ark and another like a doleful spaniel; (see Illus. 50). A small orange lustre mug with an elephant in low relief also began life holding an Easter egg.

12. Carpet Bowls

Earthenware balls, for indoor bowling, are rare items. The Hove Museum has three beauties, somewhat similar to the pottery Easter eggs in Sunderland Museum and perhaps from the same factory. They were made about 1830, and are transfer-printed with lively scenes – note the air balloon and the Maypole dancers (see illustration 52).

13. Crested China

In the 1880s Adolphus Goss was inspired to add the crest of a tourist centre to the small white porcelain ornaments produced by the W. H. Goss Pottery founded by his father. The venture was a phenomenal success, and the craze for crested china lasted until the 1930s. The majority of pieces were sold as souvenirs and gifts at seaside resorts, and took the form of anything from a lighthouse or a bathing machine to a black cat riding a bicycle. A few of the more toy-like models seem to have been aimed at the juvenile market, and one or two

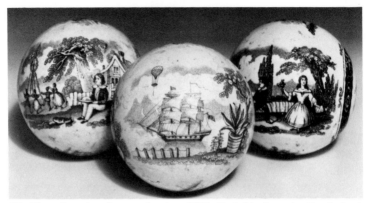

52. Transfer printed carpet bowls, *c.*1830. Probably from the Sunderland Potteries, where similar earthenware eggs were made

examples, either from Goss or rival firms, could be added to a collection of children's china. Pieces to look out for include a rare Kewpie-type unjointed doll made by Kingsway Art China, a Noah's Ark marked 'British Manufacture', a cradle made by Gemma and a rocking horse made by Grafton China.

14. Christmas and Birthday Cake Decorations
Light-weight porcelain cake decorations have a relatively short history, being preceded by edible sugar ornaments and paper 'scraps'. The earliest record I have been able to find is in a trade catalogue of 1876, when Thomas Smith & Co., Ornamental Confectioners and Importers of Foreign Fancy Goods, devoted a section to Christmas, Twelfth Night and Christening Cake Ornaments. Various cradles and cupids are listed under Christening Cake Ornaments; cradles 'with col-oured satin quilt' costing 42/− per dozen wholesale, which certainly suggests something made of porcelain rather than ephemeral sugar, gum or paper. An illustration of a '*Sylphide-sur-Piedestal*' intended for a Twelfth-Night cake, shows a graceful little bisque porcelain figure imported from France, which cost the considerable sum of 10/6d. At this price these cake decorations must have been treasured and used year after

year; some probably still survive, their original purpose quite forgotten.

Ornaments imported from France are listed all through the last quarter of the nineteenth century and the beginning of the twentieth – soldiers of various regiments, children playing, a figure of Britannia and 'other varieties too numerous to mention'. After 1918, German china figures dominated the market and the choice was immense: Santa Claus was portrayed perched on an elephant, astride an elk, descending a chimney, riding a motor bike, sitting on an igloo, and driving a team of huskies. He was accompanied by eskimo babies dressed in what can best be described as gritty snowsuits, and although these tiny ornaments are almost never marked, it is obvious from their quality and their delicately modelled faces that they were made in Germany by the same manufacturers who had the skill to produce miniature dolls for dolls' houses. Pip, Squeak and Wilfred (see p. 44) must have been made especially for the British market; not only did these lovable pets appear on Christmas cakes in their normal attitudes, but in 1936 they surpassed themselves by riding on a giraffe.

Exquisite little porcelain cradles holding microscopic babies and rocked by cupids are photographed in a catalogue of the 1920s. One feels that hundreds of these, at least, must have been kept by loving mothers after the last crumbs of the christening cake had been eaten, and here again a lucky collector may come across a treasured family heirloom. Birthday cake ornaments are naturally more plentiful, being called for every year in a child's life: they include fairy story groups, models of children with their toys and a whole menagerie of animals. Candle-holders were made in the form of animals sitting beside tubs or baskets (Illus. no. 54), with details like the animals' coats and the baskets' weave clearly shown in the moulding. Great care must be taken when cleaning these ornaments as they were coloured with water-soluble paint, which is all too easy to wash off.

Minute unjointed dolls of glazed white china – sometimes

53. Page from a trade catalogue of *c*.1930 showing German-made Christmas cake decorations

54. A group of birthday cake ornaments, German, in use in the 1930s

called 'Frozen Charlottes' after the heroine of an American ballad – were put into Christmas puddings until about 1940, after which they were no longer obtainable. The idea of putting good-luck charms into plum puddings seems to have originated from an early French custom of hiding a silver trinket or a white china 'bean' – actually a small disc topped with a tiny doll's head – in the *Gateau des Rois* served on Twelfth Night. Whoever found the bean became King of the Feast, and the following day three slices of cake, ostensibly kept back for the Holy Family, would be given to the poor.

Display

Apart from Noah's Arks I can think of no children's toys more difficult to display than nursery tea and dinner services. Much of their charm lies in the sheer number of pieces in each set, and when an entire service is spread out it does take up a surprising amount of space. A few items look charming arranged in a general display of period dolls and toys, but once a china collection has grown to a reasonable size it will inevitably spend most of the time in cardboard boxes – a great pity – unless it can be got onto narrow shelves. There may be room for these in a hall or on a landing, as they do not need to project very far; ideally they should be enclosed by glass doors, to keep out cats and dust. Perspex, or a similar material called Glodex, is much lighter than glass, and not difficult to use.

Early children's plates were more ornamental than useful, and look quite at home on an old dresser or a kitchen shelf, provided they are safely propped up. Alternatively, they can be hung on the wall by means of wire hangers. As a collection grows, however, special shelves or cabinets will almost certainly be needed.

Really small things, like cake decorations and dolls' house pieces, can easily be overlooked in a general display, and I have found cigar boxes make ideal show cases for them. Strips of thin wood are fixed across the inside of the box, forming shelves, and the simplest possible picture frame moulding is used for holding the hinged glass front.

Background is a matter of personal choice, but since children's china is by nature somewhat fussy and lavishly decorated it looks best against something fairly plain and neutral. Hessian or display felt can be used with great success. In the case of pieces decorated with storybook or cartoon characters it is interesting to show related material – postcards, books and toys for example – beside the china.

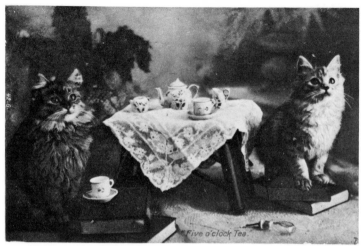

55. A postcard of 1906, 'Five o'clock Tea'. Related material of this kind adds interest to a display of children's china

No matter how a collection is displayed, or even if it has to remain packed away, meticulous labelling is essential. If labels actually on the shelves are thought to be too clinical, then a clear plan should be drawn showing the position of each piece and any information known about it. Marks of any kind should be noted, and this, as we have seen, can mean going all through a hundred-piece dinner service in search of the single plate bearing a name or mark.

Marks can be traced through Geoffrey Godden's *Encyclopaedia of British Pottery and Porcelain Marks*, a wonderful source of information about British pottery manufacturers generally. This will give the name of the maker, and dates between which the firm operated, or between which certain marks were used. Any piece bearing a Patent Office Design Registry mark or number can be dated with no trouble at all – or rather, the introduction of the design can be dated – the design itself may have been in production for many years afterwards. Between 1842 and 1883 registered designs bore a diamond mark either impressed or printed, and after 1883, a simple run of numbers was substituted, starting with No. 1 in 1884 and reaching

368,184 by 1900. Many reference books (see bibliography) include a key showing how to interpret the code letters and numbers incorporated in the angles of the diamond marks, which will provide the exact date of a design's official registration. What is perhaps not so well-known is that anyone, having worked out this date, can go to the Public Record Office at Kew and trace the original registration in the files. These files consist of immense leather-bound volumes containing the full name and address of the manufacturer in question and a 'Representation' of the design he is registering. This might be an actual sample of fabric or wallpaper, a drawing or a photograph, but in the case of ceramic items it is usually a 'pull' from the copper plate used in printing the relevant design. A day's research at Kew can be astonishingly rewarding, as apart from tracking down designs with known dates, the collector can be quite sure of chancing upon other fascinating information while browsing through the vast 'Representations' volumes. It should be noted that a reader's ticket must be obtained for admission to the Public Record Office; apply to The Keeper, Public Record Office, Kew, Surrey, with a brief indication of the purpose of your research. It is well worth the effort, as so often it is the outstanding or unusual piece that has survived in museum or private collections, while these invaluable records provide a matchless cross-section of the ordinary everyday goods being produced in nineteenth-century Britain.

Museums

Only a very few museums have displays of children's china permanently on view. Reserve collections sometimes include surprising rarities, and it is always worth asking to see any pieces that might be in store, but advance notice of a proposed visit should be given, of course, and special arrangements made with museum staff.

Some children's ware will be found both in museums specialising in ceramics generally, and in those with large toy and doll displays. Almost all museums turn out to have at least one example. A brief note should be made of every piece seen, with date, mark and attribution, as this can be a great help if one ever finds a similar example for sale.

London
Two London Museums are worth a special visit:

The Victoria and Albert Museum, South Kensington, SW7 (01 589 6371)
This museum has a highly important collection of English Pottery and Porcelain, and children's pieces currently on display include:

Staffordshire salt-glazed pottery toy cups, *c.*1745

Bow porcelain toy tea service, painted in enamel colours, with both tea-bowls and cups with handles, *c.*1750

Part of a child's tea service, Worcester porcelain, painted with blue 'Warbler' pattern and marked with pseudo-Chinese characters, with handle-less tea bowls, 1755/60

A collection of Leeds ware toy dishes, late 18th-century.

Earthenware egg, printed in lavender colour with a horse and the words 'A Horse from the Fair'. Probably from Sunderland, early nineteenth-century.

Some early nineteenth-century money-boxes, shaped like houses, from Staffordshire.

Small earthenware dolls' dishes with moulded fish, cauliflower and sauce boat, in colours. Staffordshire, late eighteenth-century; dolls' house size.

A collection of children's gift plates, transfer-printed, with moulded borders.

Mabel Lucie Attwell 'Toadstool' set of nursery china, Shelley china works, 1926.

Eric Ravilious Alphabet bowl, Wedgwood, *c.*1935.

Bethnal Green Museum, Cambridge Heath Road, E2 (01 980 3204)
The extensive display of period dolls' houses includes many examples of dolls' house china ranging in date from the 18th century to the 20th. There is a separate display of larger toy tea and dinner services and children's plates, including:

Toy tea service, *c.*1830, with green 'Beehive' transfer decoration.

Allerton's 'Girl and Dog' and 'Punch and Judy' sets, 1889/90.

'Cinderella' and 'Red Riding Hood' tea services; Ridgway's 'Maidenhair Fern' dinner service.

Children's gift plates include a group with Adam Buck style decoration enclosed in lustre rims, and one with Isaac Watts' Cradle Hymn.

Large tile panel 'Mary, Mary Quite Contrary' designed by Margaret Thompson, *c*.1900, originally in University College Hospital.

Other museums which display a fair number of children's pieces include:

Cambridgeshire
Fitzwilliam Museum,
Trumpington Street,
Cambridge
(Tel. Cambridge 69501–3)

The celebrated collection of ceramics includes several early slipware and other decorated cradles.

East Sussex
The National Toy Museum,
The Grange,
Rottingdean
(Tel. Brighton 31004)

China for dolls' houses and larger dolls can be seen here. There is a collection of toy food, white earthenware glazed with some green detail, late eighteenth or early nineteenth century. Among the toy tea-sets are an early twentieth century porcelain example, probably Continental, with the various pieces moulded in a strawberry shape and coloured pink, gold and green; and an earthenware set decorated with coloured transfer prints of Felix the Cat. (*c*.1925).

Brighton Museum and
Art Gallery,
Church Street,
Brighton
(Tel. Brighton 603005)

Only part of the fabulous Willett Collection of documentary and commemorative pottery can be displayed at any one time, but visitors can always be sure of finding much of interest. Many 'commemoratives' were intended for children, and the museum has a good number of other children's pieces: for example, 'Reward' mugs and plates with improving messages. One of these, bearing a picture of a boy comforting a little girl, has the verse:

At times I own I used to pout,
And throw my bread and milk about.
Who gave me his, and went without?
My Brother.

A more modern exhibit is a cup and saucer featuring Princess Elizabeth – 'Our Empire's Little Princess born April 21st 1926' – complete with Marcus Adams photograph.

Hove Museum of Art,
19 New Church Road,
Hove, BN3 4AB.
(Tel. Brighton 779410)

Many unusual pieces including a pair of early nineteenth-century carpet bowls, salt-glaze money-boxes and an outstanding toy tea-set showing Queen Victoria's two eldest children in a goat-cart, with Windsor Castle in the background (illus. nos. 51, 52 and coloured frontispiece).

Gloucestershire
Sudeley Castle,
Winchcombe
(Tel. Winchcombe 602308)

Note: The Castle is
normally closed in the
winter months

A new (1981) attraction at Sudeley (once the home of Katherine Parr) is Kay Desmonde's Toy Collection. This is a feast for nostalgia addicts, with hundreds of beautiful dolls and toys to be admired, together with a variety of children's china. Felix the Cat items and Christmas cake 'snow-babies' are well to the fore.

Isle of Wight
Arreton Manor, near Newport
(Tel. Arreton 255)

Lilliput Doll Museum,
High Street,
Brading
(Tel. Brading 231)

Summer visitors to the Isle of Wight could probably fit in all three collections. Arreton Manor has a good display of toy tea and dinner services, while fresh delights are constantly being added to the Lilliput

Osborne House
East Cowes
(Dept. of Environment)

Doll Museum. At Osborne, Queen Victoria's favourite residence, the Royal children's scaled-down domestic equipment is preserved in the Swiss Cottage, and includes miniature pottery.

Kent
The Precinct Toy Collection,
38 Harnet Street,
Sandwich

Open: Easter to the
end of September

A wonderful collection of dolls and toys, with several tea and dinner services. A group of dolls is seated round a tea table laid with toy china, a *tableau* which could easily be copied by collectors for some special occasion.

Royal Tunbridge Wells Museum
and Art Gallery,
Civic Centre,
Tunbridge Wells
(Tel. Tunbridge Wells 26121)

Another outstanding toy collection, including a child's porcelain tea-set with hand-painted floral design, still in its original wooden and cardboard box: French, *c.*1870. Miniature jelly moulds, one with an acorn design, of *c.*1900.

Oxfordshire
The Rotunda,
Grove House,
Iffley Turn,
Oxford

Mrs. Graham Greene's private collection of dolls' houses is open to the public on summer Sunday

(children under 16
not admitted)

afternoons. The furnishings include, of course, eighteenth- and nineteenth-century dolls' house china.

South Yorkshire
Sheffield City Museum,
West Park,
Sheffield 10.
(Tel. Sheffield 27226–7)

The extensive ceramic collection contains several interesting items of children's ware.

Staffordshire
Gladstone Pottery Museum,
Uttoxeter Road,
Longton,
Stoke on Trent.
(Tel. Stoke on Trent 319232)

This new award-winning museum covers the whole story of the British pottery industry, with beautiful displays housed in an early Victorian Potbank complete with spectacular Bottle Ovens. Although there is not much children's ware on view, a visit is well worthwhile. Some nursery rhyme tiles are currently being displayed.

West Sussex
Potter's Museum of Curiosity,
6 High Street,
Arundel
(Tel. Arundel 882420)

Besides the famous animal *tableaux* this remarkable museum has a very well-equipped dolls' house with a lot of china, and, separately displayed, an exquisite porcelain dinner service, dolls'-house size, complete with salad plates.

Worthing Museum
and Art Gallery,
Chapel Road,
Worthing
(Tel. Worthing 39189)

The museum possesses a large assortment of late nineteenth-century tea and coffee sets, some incomplete, with transfer-printed decoration. An earlier dinner service is printed with a blue-and-white rural scene and impressed with the maker's name of 'Hackwood', *c.*1830–50. Florence Upton's Golliwogg and two wooden dolls feature on a single tea plate, evidently once part of a nursery set.

Scotland
Museum of Childhood,
38 High Street,
Edinburgh
(Tel. 031 556 5447)

A superb museum covering all aspects of childhood, and displaying a wide variety of ceramics intended for children.

Wales
Llandudno Doll Museum,
Masonic Street,
Llandudno, LL30 1BW
North Wales
(Tel. Llandudno 76312)

Open Easter to end of
September.

Examples of children's china are displayed among a collection of over a thousand period dolls. The pieces range from dolls'-house crockery to full-size nursery plates. A toy tea-set of the 1930s is decorated with photographs of Princess Elizabeth and Princess Margaret Rose.

Museum of Childhood,
Water Street,
Menai Bridge,
Anglesey,
North Wales
(Tel. Menai Bridge 712001)

Open Easter to October,
winter months by arrangement.

One room is devoted entirely to pottery, glass and commemoratives. There are examples of Mary Gregory glass, decorated tiles, plates, mugs and toy tea and dinner services. There is commemorative pottery from the early 1800s to the present day, including many Prince of Wales items. Plates and tiles are suspended on perforated hardboard, an effective arrangement which could easily be copied by collectors.

The Glynn Vivian Art Gallery and Museum,
Alexandra Road,
Swansea, SA1 5DZ.
(Tel. Swansea 55006)

This museum has some most interesting early children's items produced locally: several plates bear the Dillwyn mark (Swansea) and others were made in Glamorgan. Note the variety of moulded borders – rose-and-tulip, bird-and-flower and others. An early nineteenth century Glamorgan plate (Baker Bevans & Irwin) is decorated with the Isaac Watts verse 'How doth the little busy bee . . .'. Other plates are inscribed with children's names – 'Hannah' and 'A Trifle for Billy'.

Swansea Museum,
Victoria Road,
Swansea.
(Tel. Swansea 53763)

Visitors to the Glynn Vivian Art Gallery should leave time for a visit to Swansea Museum, which also has a large collection of Swansea china.

Bibliography

Sandy Andrews *Crested China. The History of Heraldic Souvenir Ware.* Springwood Books Ltd, 1980.

Paul Atterbury (ed.) *English Pottery and Porcelain: Historical Survey* (contains a short chapter on children's mugs by K. M. McClinton) Peter Owen, 1980.

David Battie and Michael Turner *Price Guide to Nineteenth and Twentieth Century Pottery.* Antique Collectors Club, 1979.

A. W. Coysh *Blue and White Transfer Ware 1780–1840.* David and Charles, 1970.

Blue-Printed Earthenware, 1800–1850, David & Charles, 1972.

Rena Cross *China Repairs and Restoration.* W. Foulsham & Co. Ltd, 1972.

Geoffrey Godden *Encyclopaedia of British Pottery and Porcelain Marks.* Barrie & Jenkins, 1968. *Illustrated Encyclopaedia of British Pottery and Porcelain.* Barrie & Jenkins, 1980.

Vivien Greene *English Dolls' Houses of the Eighteenth and Nineteenth Centuries.* Batsford, 1955 reprinted Bell & Hyman, 1979.

Bernard and Therle Hughes *Collecting Miniature Antiques.* Heinemann, 1973.

Terence A. Lockett *Davenport Pottery and Porcelain 1793–1887.* David and Charles 1972 *Collecting Victorian Tiles.* Antique Collectors' Club, 1979.

John and Jennifer May *Commemorative Pottery 1780–1900.* Heinemann, 1972.

K. M. Clinton *Antiques in Miniature.* Barrie & Jenkins, 1972.

E. Morton Nance *Pottery and Porcelain of Swansea and Nantgarw* (1942) (includes many illustrations of children's gift plates), Hans Van Lemmen *Tiles – A Collector's Guide.* Souvenir Press, 1979.

H. Wakefield *Victorian Pottery* Barrie & Jenkins (1962).

Susan Wells *Mend your own China and Glass*. G. Bell, 1975

The Doulton Story. Royal Doulton Tableware Limited.

The Potteries of Sunderland and District. Sunderland Public Libraries, Museum & Art Gallery.

Children and Food. Catalogue of an Exhibition at Preston Manor, Brighton, 1977.

The Age of Innocence. Catalogue of an exhibition of The Child and his World, Holburne Museum, Bath, 1969.

Index

Numbers in italics refer to illustrations